making masks

by Violaine Lamérand

Translated by Cheryl L. Smith

Reading Consultant:
Dr. Robert Miller
Professor of Special Education
Minnesota State University, Mankato

Bridgestone Books

an imprint of Capstone Press
Mankato, Minnesota

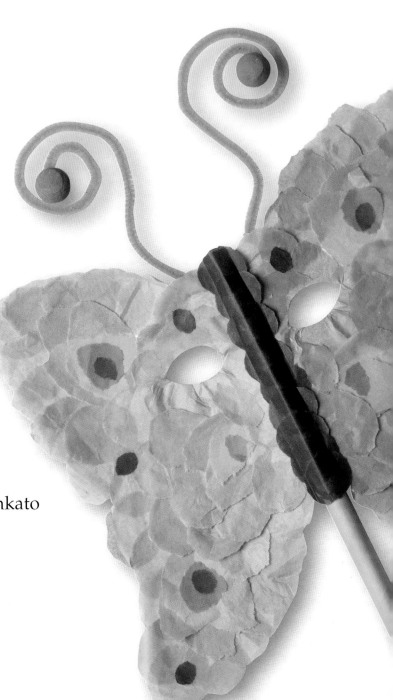

Table of Contents

words to know

corrugated cardboard (KOR-uh-gayt-ed KARD-bord)—cardboard formed with alternating ridges and grooves on the inside

craft foam (KRAFT FOHM)—a thin sheet of foam that can be cut, stapled, or glued to make crafts; craft foam is available at many craft stores.

crepe paper (KRAPE PAPER)—thin crinkled paper, often used as a party decoration or in crafts

elastic string (ee-LASS-tik STRING)—thin cord that can stretch out and return to its original size and shape

raffia (RAH-fee-uh)—the fiber of the raffia palm tree; this strawlike fiber often is used in crafts.

slit (SLIT)—a long, narrow cut

varnish (VAR-nish)—a thick liquid used to protect objects; varnish dries clear.

Originally published as *Masques* © 2000 by Editions Milan.

Bridgestone Books are published by Capstone Press
151 Good Counsel Drive, P.O. Box 669, Mankato, Minnesota 56002
http://www.capstone-press.com

Library of Congress Cataloging-in-Publication Data
Lamérand, Violaine.
 Making masks / by Violaine Lamérand; translated by
 Cheryl L. Smith.
 p. cm.—(Step by step)
 Includes index.
 Summary: Provides detailed instructions for making fourteen
masks, representing a clown, a fish, a tree, and more.
 ISBN 0-7368-1476-0 (hardcover)
 1. Mask making—Juvenile literature. [1. Mask making. 2. Masks.
3. Handicraft.] I. Title. II. Step by step (Mankato, Minn.)
TT898 .L36 2003
731'.75—dc21
 2002002174
1 2 3 4 5 6 07 06 05 04 03 02

3 9082 08557 4021

Editor:
Rebecca Glaser

Photographs:
Milan/Dominique Chauvet;
Capstone Press/Gary Sundermeyer

Graphic Design:
Sarbacane

Design Production:
Steve Christensen

Little Tricks

Use tracing paper to trace this pattern. Then trace the pattern onto cardboard or a paper plate to make a mask. Make sure there is a distance of 1¼ inches (3 centimeters) between the eyes.

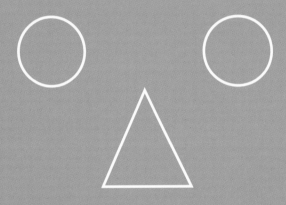

Friendly Advice

→ You can use shoeboxes or cereal boxes for the base of your masks. Paint the boxes white or cover them with white paper before painting them in color.

→ Ask an adult to help you cut thick cardboard.

To cut out the eyes, poke your scissors in the middle of the circle and cut it out, turning around the circle. →

You can also use a round stamp cutter and a hammer to cut out the eyes. Place a board under your work to protect the table. This method works well when you make many masks with a group of people. ←

For small masks, make a knot at each end of an elastic string. With a stapler, attach the string to the mask. →

Poke two holes in a large mask and use two pieces of elastic string to hold the mask in place. ←

5

Clown Mask

You Will Need:

- 2 paper plates
- Scissors
- Stapler
- Cup from an egg carton
- Paint
- Paintbrush
- 2 colors of crepe paper
- 2 rubber bands
- Glue
- Wire

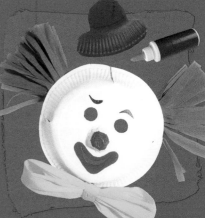

1 Cut four slits in the edge of the paper plate. Staple the two sides of each slit together. Cut out the eyes and the nose, following the pattern on page 4. Cut out a mouth.

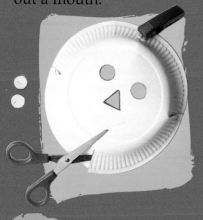

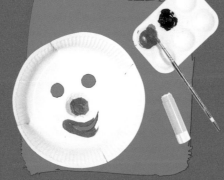

2 Glue a cup from an egg carton over the nose. Paint the nose and the smile red. Paint the eyebrows.

3 Cut a strip of crepe paper and staple it to make a bow tie. Make two bands of crepe paper. Cut the crepe paper into strips for the hair. Hold them in place with a rubber band.

4 Glue the hair and bow tie to the paper plate. Cut out a hat from the second paper plate. Paint the hat and glue it onto the clown's head. Attach a crepe paper flower to the wire and stick it on the hat. Fold over the end of the wire and wrap it with tape.

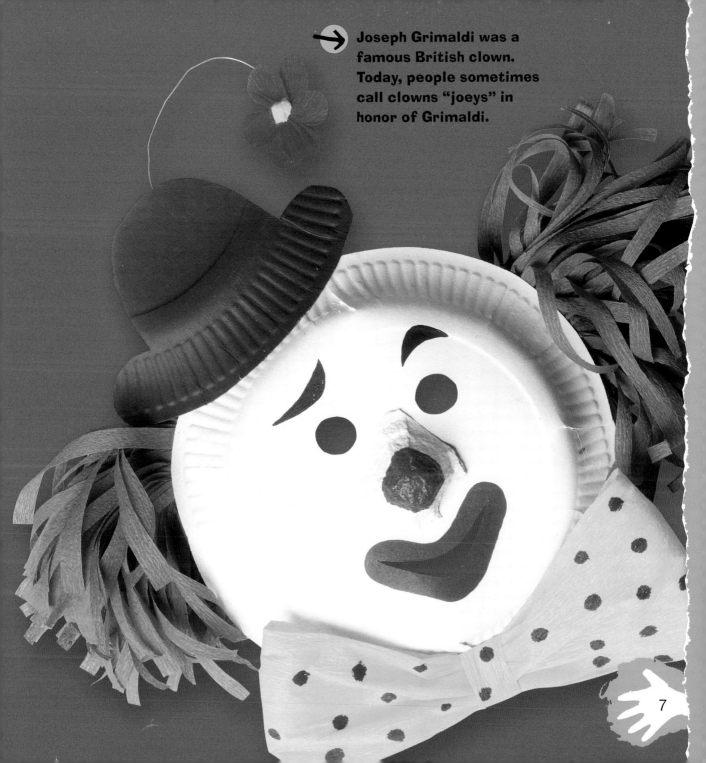

Joseph Grimaldi was a famous British clown. Today, people sometimes call clowns "joeys" in honor of Grimaldi.

Fish Mask

3 Cut fins out of another color foam and glue them on top and on the bottom of the fish. Cut two circles with a hole and glue them on to make the eyes.

2 Cut along the line. Staple the two parts together and cut out a half circle for the mouth. Make holes for the eyes. Cut two fins out of the scraps of craft foam.

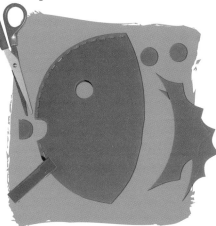

1 Use the plate to trace a half circle on each large piece of craft foam.

4 For the mouth, cut two strips of craft foam about 3 inches (8 centimeters) long. Glue them around the hole for the mouth.

8

 Fish do not have eyelids. They cannot close their eyes, so they sleep with their eyes open.

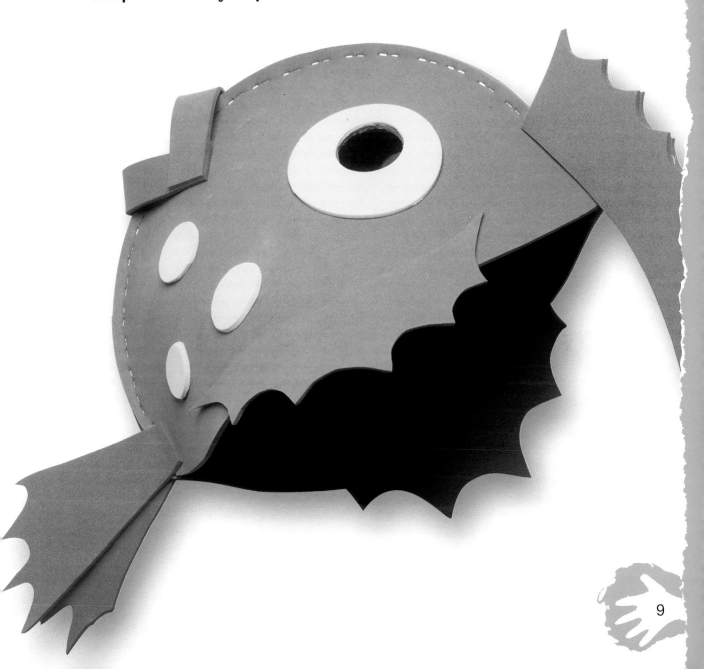

Apple Tree Mask

You Will Need:

- **Brown corrugated cardboard**
- **Paint**
- **Paintbrush**
- **Green and red tissue paper**
- **Glue**
- **Scissors**
- **Wire**
- **Wire cutter**

1 Draw a large tree on a piece of cardboard. The cardboard should fold the long way. The trunk must be 8 inches (20 centimeters) wide to hide your face. Cut out the tree. Make holes for the eyes and nose.

2 Paint the trunk by mixing your colors directly on the cardboard. Let the paint dry.

3 Cut squares of green tissue paper. Wrinkle them without squeezing too hard and glue them to the tree. Glue on a few smaller red balls to make apples.

4 Cut out some birds from the cardboard. Paint them and attach them to pieces of wire. Put the wire into the ridges of the cardboard.

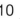

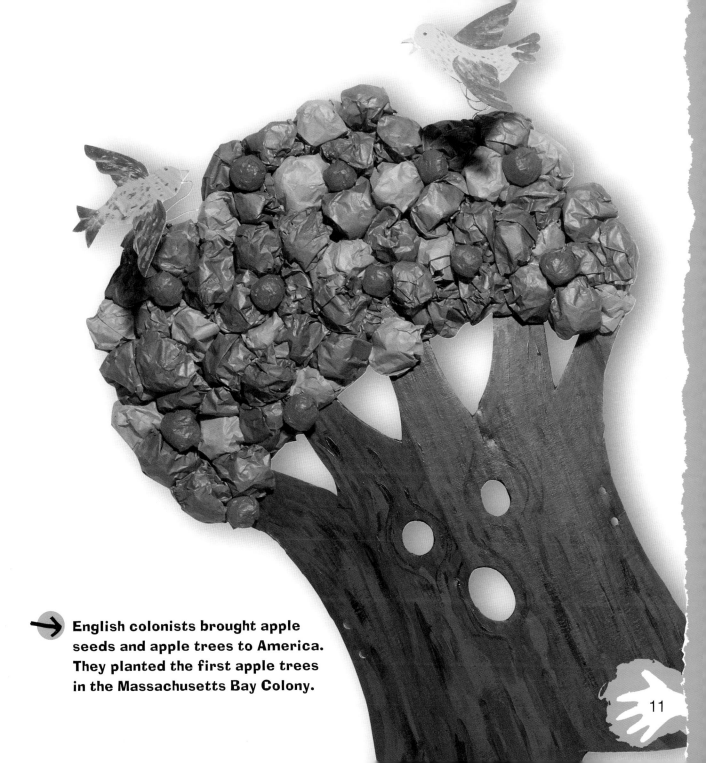

English colonists brought apple seeds and apple trees to America. They planted the first apple trees in the Massachusetts Bay Colony.

witch Mask

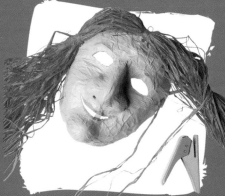

You Will Need:

- **A white mask**
- **Modeling clay**
- **Petroleum jelly**
- **5 sheets of newspaper**
- **Wallpaper paste mixed with water**
- **1 sheet of white paper**
- **Scissors**
- **Paint**
- **Paintbrush**
- **Paper punch**
- **Raffia**
- **Glue**

1 On the white mask, form a large nose and a chin with modeling clay. Spread petroleum jelly over the whole mask with your fingers.

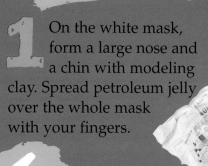

2 Wrinkle a sheet of newspaper. Brush wallpaper paste on both sides and place it immediately on the mask. Make four more layers of newspaper in the same way. Then add the white sheet of paper. Keep the folds to make wrinkles. Let the glue dry.

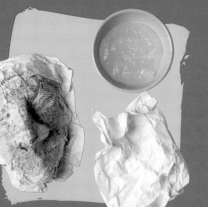

3 Remove the white mask and the modeling clay. You can use them again. Trim the edges of the newspaper. Cut out holes for the eyes and the mouth. Paint your mask.

4 Make one hole on top of the mask and one on each side. Attach the raffia by passing a strand through the three holes and tying a knot. Glue a small square of white paper behind the mouth to make a tooth.

Raffia comes from the raffia palm tree. This tree grows on the island of Madagascar near eastern Africa, and on Africa's eastern coasts. The leaves of the raffia tree are made into the fibers used for crafts.

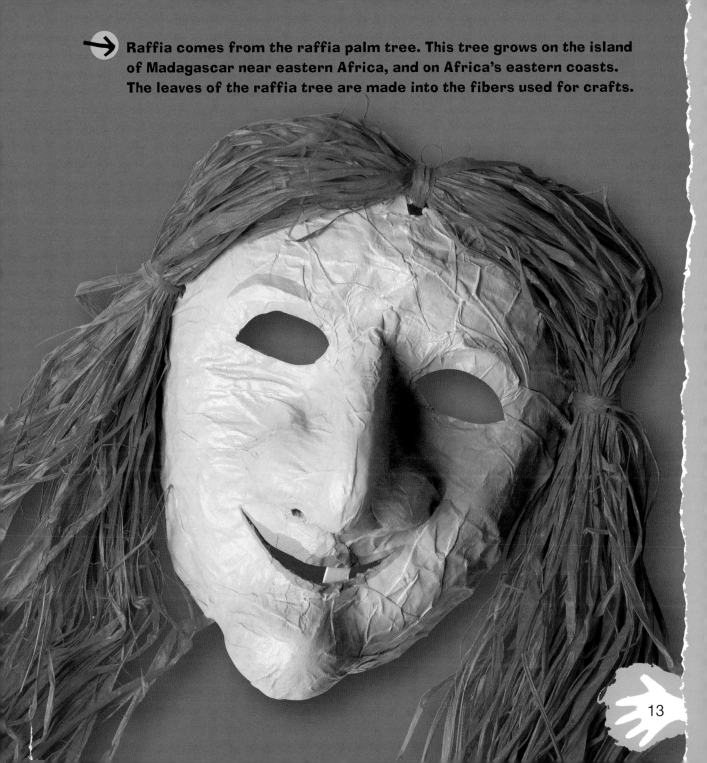

Owl Mask

1 Cut out two cups and a point from an egg carton to make the beak. Make a hole in the center of the two cups.

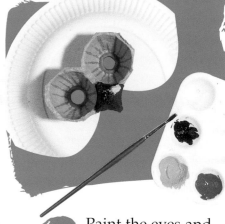

3 Paint the eyes and the beak.

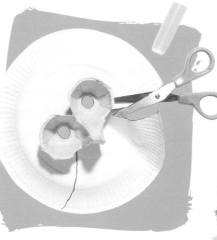

2 Place the cups on a paper plate and trace the holes for the eyes. Cut out the circles from the paper plate, then glue the cups onto the plate. Cut off the bottom of the plate.

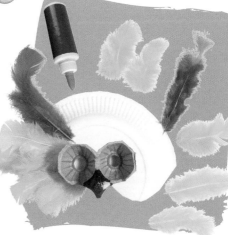

4 Glue feathers around the eyes.

14

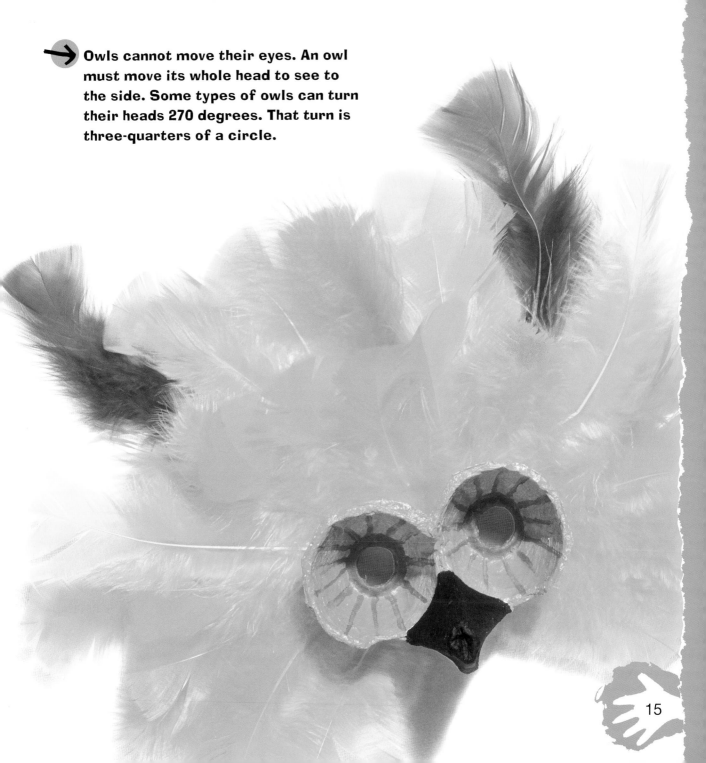

Owls cannot move their eyes. An owl must move its whole head to see to the side. Some types of owls can turn their heads 270 degrees. That turn is three-quarters of a circle.

15

Butterfly Mask

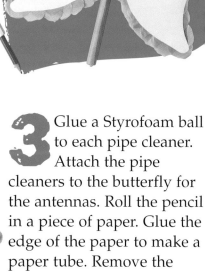

2 Fold the tissue paper into several thicknesses and tear out circles. Layer the circles over each other. Glue them to the butterfly.

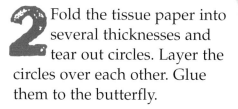

3 Glue a Styrofoam ball to each pipe cleaner. Attach the pipe cleaners to the butterfly for the antennas. Roll the pencil in a piece of paper. Glue the edge of the paper to make a paper tube. Remove the pencil and glue the tube to the butterfly at the folds.

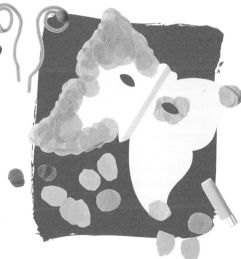

1 Fold one sheet of paper in half. Draw half of a butterfly and cut it out. Open the sheet of paper. Make two folds the length of the body. Cut out eyes 1¼ inches (3 centimeters) apart.

16

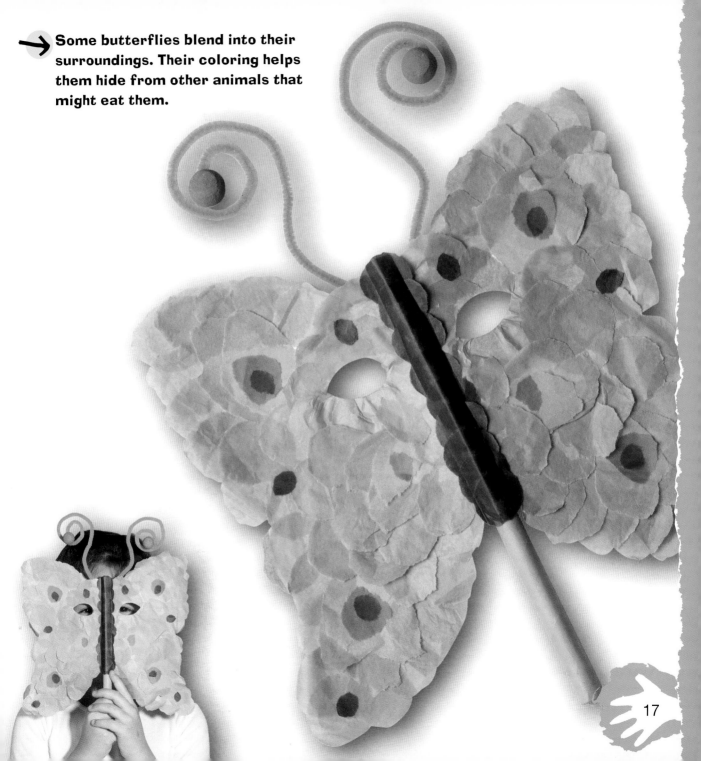

Some butterflies blend into their surroundings. Their coloring helps them hide from other animals that might eat them.

17

Robot Mask

You Will Need:

- Cereal box
- Aluminum foil
- Scissors
- Glue stick
- 3 small plastic yogurt cups
- Double-sided tape
- Empty matchbox
- Colored paper
- 2 pipe cleaners
- 2 sink drain strainers
- Brass fasteners
- Pencil
- Styrofoam ball
- Cardboard

2 Cut a circle in the bottom of two yogurt cups. Put double-sided tape on the edges of all three cups. Cut a dial out of colored paper and a needle out of the cardboard. Cover the matchbox with colored paper.

3 Stick on all the parts with double-sided tape. Attach the pipe cleaner and the sink drain strainers with brass fasteners. Place the Styrofoam ball on the end of the pipe cleaner. Roll another pipe cleaner around a pencil to make a spring. Poke a hole in the top of the box and put the pipe cleaner into it.

1 Cut a large oval shape into the back of the cereal box. On the other side, cut two circles 1¼ inches (3 centimeters) apart. Put glue on the box and cover it with aluminum foil.

18

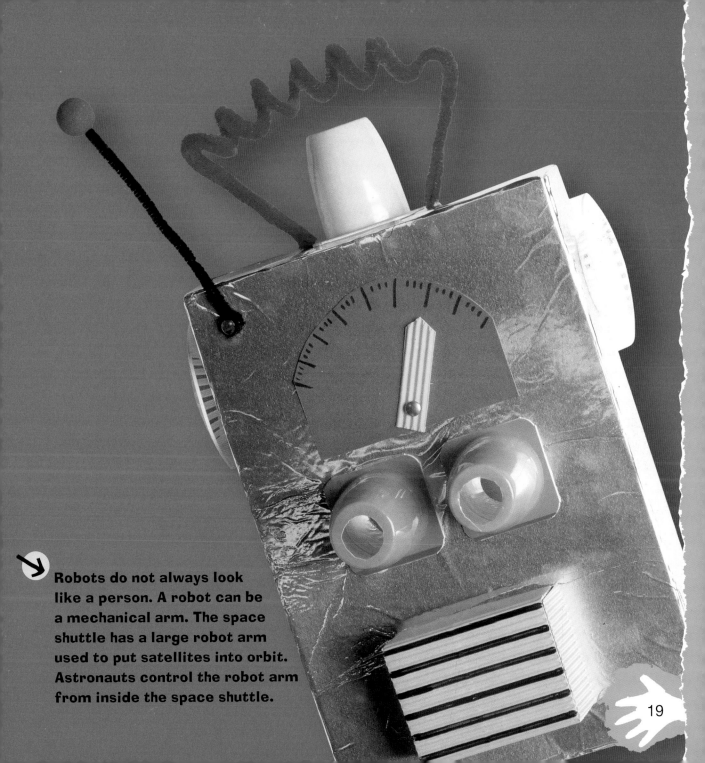

Robots do not always look like a person. A robot can be a mechanical arm. The space shuttle has a large robot arm used to put satellites into orbit. Astronauts control the robot arm from inside the space shuttle.

19

Star Mask

You Will Need:

- Paper plate
- Scissors
- Cardboard
- Glue
- Paint
- Paintbrush
- Pencil
- Glitter in a tube
- Wire
- Wire cutter
- 5 beads

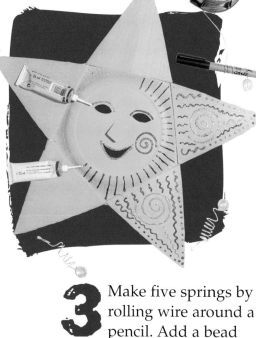

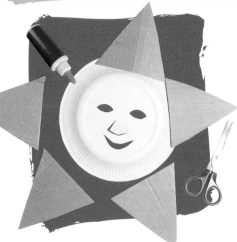

1 Cut out a face in the center of the paper plate. Use the pattern on page 4. Cut out five triangles from the cardboard. Make sure the ridges go up and down. Glue the triangles around the plate.

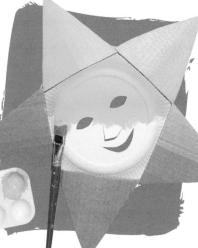

2 Paint the star and let it dry.

3 Make five springs by rolling wire around a pencil. Add a bead to the end of each spring. Poke the other end of each spring into the cardboard at each star point. Fold over the end of the wire and wrap it with tape. Decorate the star with glitter in a tube and let it dry.

20

Not all stars are yellow. Blue stars are hotter than yellow stars. **Red** stars are cooler than yellow stars.

21

Bear Mask

You Will Need:

- 8-inch (20-centimeter) square of craft foam
- Small sheet of craft foam, 3½ inches by 5 inches (9 centimeters by 13 centimeters)
- Foam scraps
- Scissors
- White glue
- Stapler

1 Cut the corners of the foam square so they are round. Cut out a small triangle at the bottom. Round off the corners of the smaller rectangle to form the snout. Cut a small triangle in the bottom.

2 Make two holes for the eyes 1¼ inches (3 centimeters) apart. Staple the two edges of the triangles. Then press the staples into the foam to hide them.

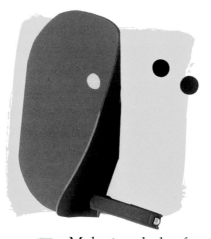

3 Cut two large circles and two smaller ones for the ears. Cut off the bottom of the ears. Glue the small circles to the larger ones. Staple the bottom of the ears. Cut out the smile and the nose.

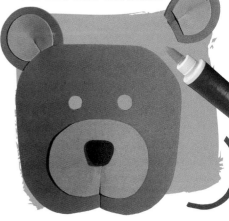

4 Glue the snout to the mask by lining up the edges of the triangle with the stapled edge of the bear face. Glue on the nose, the mouth, and the ears.

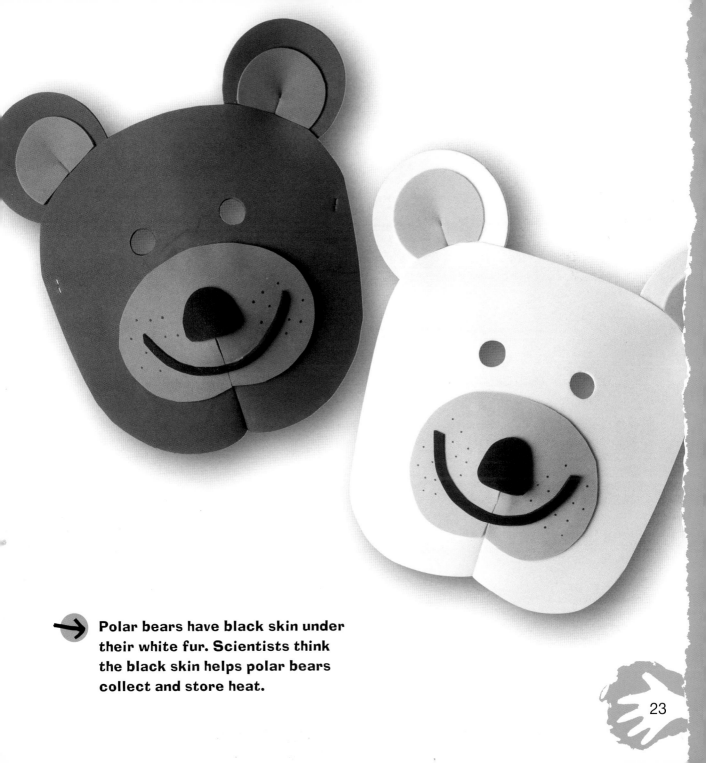

Polar bears have black skin under
their white fur. Scientists think
the black skin helps polar bears
collect and store heat.

23

Alien Mask

You Will Need:
- **30-egg carton**
- **Scissors**
- **Cardboard tube**
- **Glue**
- **Paint**
- **Paintbrush**
- **Pipe cleaners**

2 Glue the cardboard tube under the eyes. Paint the eyes white and the rest of the face another color. When the paint is dry, add spots. Do not forget to paint eyeballs. Cut out two ears from the rest of the egg tray and paint them. Glue them on when they are dry.

3 Make springs by rolling the pipe cleaners around a pencil. Glue the springs to the back of the mask. Curl a piece of pipe cleaner and glue it in the tube to make the tongue.

1 Cut the egg carton into a square so that you have five cups on each side. Tip it diagonally and cut out two holes for eyes in a row of four cups. Make a slit in the middle cup below the eyes.

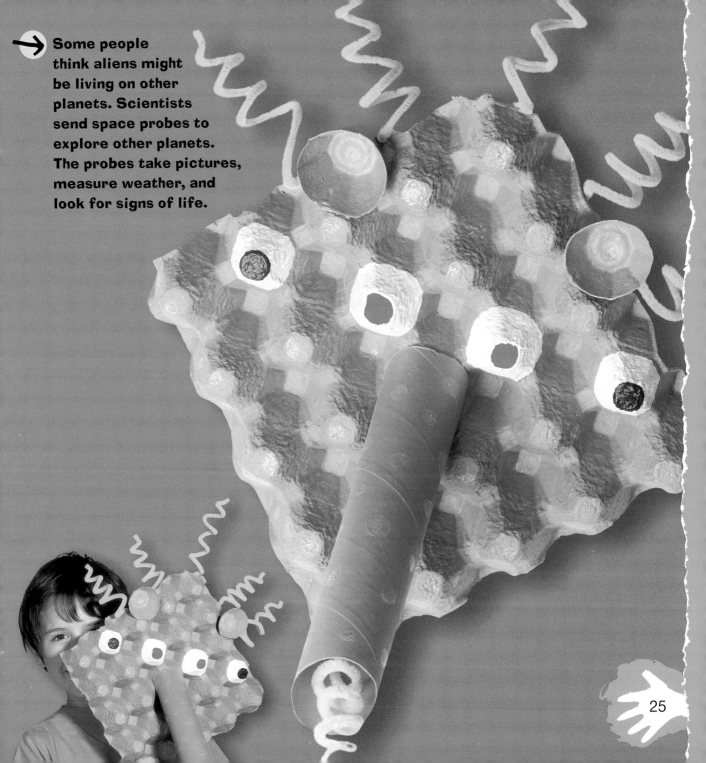

Some people think aliens might be living on other planets. Scientists send space probes to explore other planets. The probes take pictures, measure weather, and look for signs of life.

King and Queen Masks

You Will Need:
- **White mask**
- **Paint**
- **Paintbrush**
- **Crepe paper**
- **Stapler**
- **Glue**
- **Corrugated paper**

1 Paint the mask and let it dry.

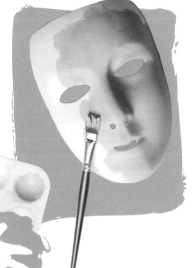

2 **The King:** Staple two bands of crepe paper to make the hair. Twist a bit of crepe paper to make the beard. Twist both ends and the middle of a long band to make the mustache.

The Queen: Braid three strips of crepe paper and staple each end of the braid. Attach a braid to each side of the mask. Place one end of the braid on the outside and the other on the inside of the mask.

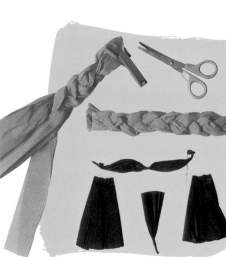

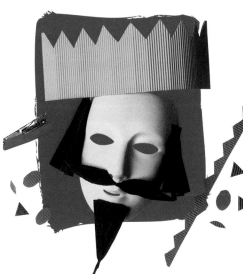

3 Glue all the pieces on the mask. Cut out a strip of corrugated paper to make the crown and glue it to the forehead. Staple the ends together. Decorate the crown with colored shapes of paper.

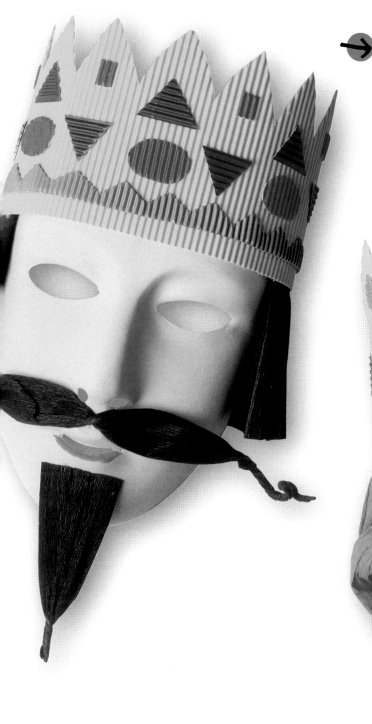

Dress up as a playing card with these masks. Kings, queens, and jacks are called face cards. In many card games, face cards are worth 10 points.

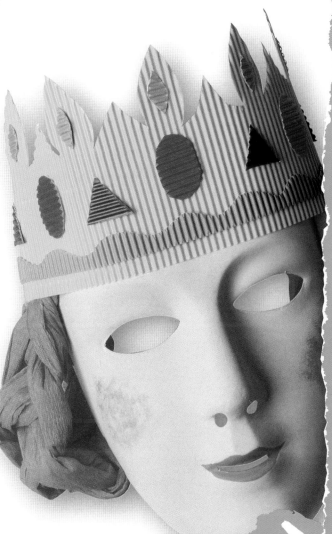

Ladybug Mask

1 Blow up the balloon. Tear strips of newspaper. Put wallpaper paste on both sides of the strips and put them on the balloon. Cover one side of the balloon with four layers of crisscrossed strips of newspaper. Finish with strips of white paper. Let it dry.

3 Paint the mask to look like a ladybug. You can varnish your mask.

2 Pop the balloon. Cut off the rough edges on your mask and make two round holes for the eyes.

4 Paint two Styrofoam balls black. After they are dry, glue a ball to each end of the pipe cleaner. Glue these antennas to the top of the mask.

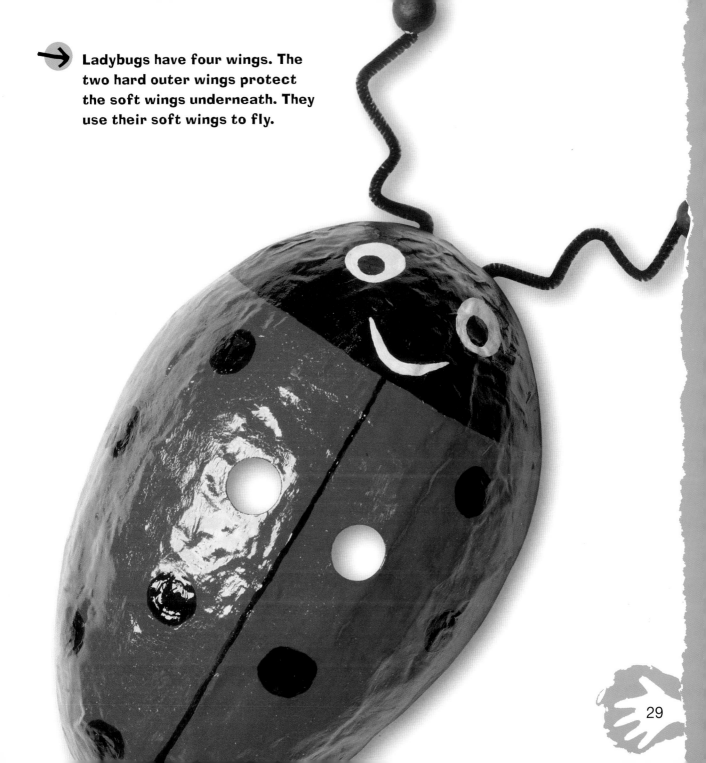

Ladybugs have four wings. The two hard outer wings protect the soft wings underneath. They use their soft wings to fly.

29

Scary creature Mask

You Will Need:

- Large, square piece of corrugated cardboard
- Paint
- Paintbrush
- Cork
- Cardboard scraps
- Scissors
- Glue
- Yarn or string
- 2 corks

1 The cardboard must bend the long way. Cut out two eyes and the nose by following the pattern on page 4. Paint the cardboard. Let it dry.

2 Spread paint on the end of a cork and stamp dots on the cardboard.

3 Cut out a small square of cardboard and paint it. Fold it and glue it on the nose. Make the mouth, teeth, and two horns from cardboard. Glue them to the mask. Pull apart the strands of yarn to fray it. Glue pieces of frayed yarn to the mask. Glue two painted corks on the bottom.

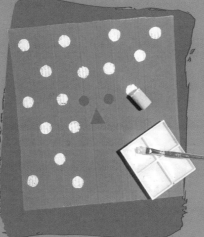

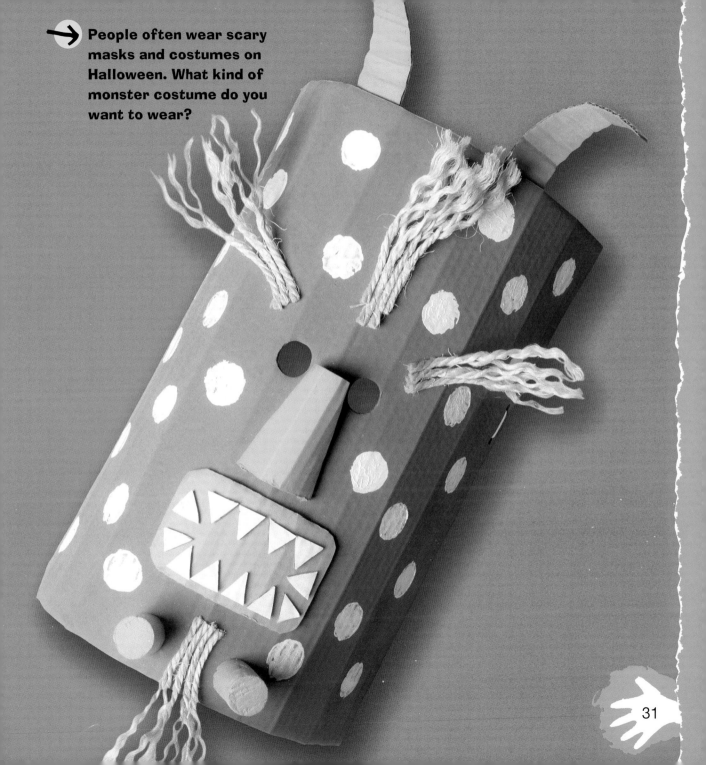

People often wear scary masks and costumes on Halloween. What kind of monster costume do you want to wear?

index

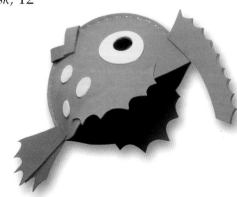